THIS JOURNAL BELONGS TO:

Copyright © 2017 by Clarkson Potter

All rights reserved.
Published in the United States by Clarkson Potter/Publishers,
an imprint of the Crown Publishing Group,
a division of Penguin Random House LLC, New York.
crownpublishing.com
clarksonpotter.com

CLARKSON POTTER is a trademark and POTTER
with colophon is a registered trademark of
Penguin Random House LLC.

ISBN 978-0-451-49776-5

Printed in China

Book and Cover design by Lise Sukhu
Illustrations by Lise Sukhu
Written by Emma Brodie

Photography Credits
front cover: pink drink umbrella, iStock by Getty/Dawn Mayfarth.
back cover: gold glitter, iStock by Getty/surachetkhamsuk; ice cream sandwich,
iStock by Getty/gvictoria; strawberry, iStock by Getty/AlexStar; pink doughnut,
iStock by Getty/Gizelka; pineapple, Shutterstock/Alex Staroseltsev; white life
preserver, iStock by Getty/© Tim Mainiero; pool float, iStock by Getty/Anton
Snarikov; red sunglasses, iStock by Getty/Porechenskaya; plastic flamingo, iStock
by Getty/David Dea; yellow pool float, Shutterstock/StacieStauffSmith Photos;
colorful pool float, Shutterstock/Kletr; paper drink umbrella, iStock by Getty/Bra-
vissimoS. title page and page 21: yellow pool float, Shutterstock/StacieStauffSmith
Photos; pages 4–5, 50–51, 80–81, 110–111: cassettes, iStock by Getty/naumoid;
page 12: vintage woman lounging, Shutterstock/Everett Collection; pages 22–23,
34–35, 66–67, 96–97: large cassette (cassette spread), iStock by Getty/filonmar;
page 33: tennis racket, iStock by Getty/C-You; page 42: vintage woman and pool,
Shutterstock/Everett Collection; page 43: colorful pool float, Shutterstock/Kletr;
page 44: pool float, iStock by Getty/Anton Snarikov; page 57: marshmallow on
stick, iStock by Getty/leschnyhan; page 58: monkey, iStock by Getty/Ghostl / crow,
iStock by Getty/GlobalP / rabbit, iStock by Getty/5second; page 58: flying eagle,
iStock by Getty/igorkov / lion, iStock by Getty/EcoPic / wolf, iStock by Getty/Iakov
Filimonov / squirrel, iStock by Getty/Ossiridian; page 107: plastic flamingo, iStock
by Getty/David Dea; pages 118–119: tie-dye, iStock by Getty/strathroy.

10 9 8 7 6 5 4 3 2

First Edition

BEST OF SUMMER

YEARBOOK
AND JOURNAL

Clarkson Potter/Publishers
New York

TOP 10 SONGS FOR SUN-FUN TIMES:

10.

9.

8.

1.

6.

THE CABINET

PRESIDENT

NAME:

BIO:

VICE PRESIDENT

NAME:

BIO:

TREASURER

NAME:

BIO:

HOMELAND SECURITY CHIEF

NAME:

BIO:

PRESS SECRETARY

NAME:

BIO:

CHIEF OF STAFF

NAME:

BIO:

SPEECH WRITER

NAME:

BIO:

PROFESSIONAL FIXER

NAME:

BIO:

SECRETARY OF STATE

NAME:

BIO:

SECRETARY OF THE INTERIOR

NAME:

BIO:

LOBBYIST

NAME:

BIO:

INTERN

NAME:

BIO:

HOW TO GIVE YOURSELF A TEMPORARY TATTOO
↬ BY (CAREFULLY) HARNESSING THE POWER OF THE SUN ☀

YOU NEED:

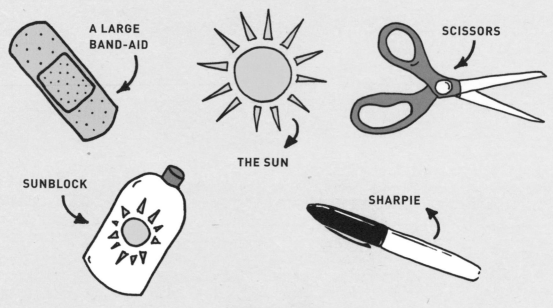

A LARGE BAND-AID

THE SUN

SCISSORS

SUNBLOCK

SHARPIE

TO DO:

1. Decide on a cute shape for your semipermanent tattoo. Or, even better, let your friends in on the decision and create a fun, semipermanent friendship tattoo!

2. Using a Sharpie, trace that shape onto the flap of a Band-Aid, leaving the waxed paper over the adhesive side.

3. Leaving the adhesive paper attached, cut out the shape you traced on the Band-Aid.

4. Decide where you want your semipermanent tattoo.

5. Peel off the adhesive paper from the Band-Aid and adhere the Band-Aid cutout to your body.

6. Apply sunscreen to your whole body and go play in the sun.

7. Leave the Band-Aid on and live your life.

8. Keep living your life and don't take off the Band-Aid.

9. Let as much time go by as you can without taking off the Band-Aid.

10. Retrace the shape and reapply the Band-Aid if the original Band-Aid deteriorates.

11. YOU ARE YOUR COMMITMENT TO THE BAND-AID.

12. When 2 weeks of this ceaseless effort have passed, remove the Band-Aid and residual Band-Aid scuzz from the skin area.

13. The Band-Aid should have protected skin from the sun, preserving the cutout shape.

14. This should work for pale to dark skin tones—if you are very, very pale, be careful of overexposure. If you are very, very dark, it may take an additional week to show results.

TATTOO DESIGN IDEAS:

SUMMER SUPERLATIVES

COULD HAVE BEEN
A SUN WORSHIPPER

FEARS THE LIGHT

MOST LIKELY TO BURN

MOST LIKELY TO TAN

WHAT'S AT THE CENTER
OF YOUR SOLAR SYSTEM?

CUT OUT TRIANGLE-SHAPED IMAGES OF EVERYTHING THAT YOU
AND YOUR PALS LOVE THIS SUMMER AND PASTE
THEM AROUND THIS CIRCLE TO CREATE
THE SPOKES OF A SUNBURST.

← PASTE HERE →

WHAT WAS THE MOST EXHILARATING THING THAT HAPPENED OUTDOORS
WITH YOU AND YOUR FRIENDS RECENTLY? WRITE IT DOWN,
AND DON'T LEAVE OUT ANY DETAILS.

FAVORITES GRID

NAME	NEVER WITHOUT	CRAVES
(EXAMPLE) LUCY	FAVORITE SUNGLASSES	STARBURST

ALWAYS FOUND WITH (PERSON)	CAN'T STAND	WOULD NEVER BE CAUGHT DEAD WEARING	TOTALLY OVER
CIARA	BOREDOM	A VISOR ☹	SUMMER READING

TOP 10 PUMP-UP SONGS:

10. _____

9. _____

8. _____

7. _____

6. _____

HOW TO MAKE BANK
IN THE CITRUS BUSINESS

BUSINESS PLAN ONE: *ORANGE WEDGES*

Scorched at a soccer game? Parched on the pavement? Have no fear, orange wedges are here. These perennial classics among moms and bleacher residers pack a punch that is oh so economical. Be the most popular purveyor of game-side nutrients this summer with these killer snacks.

TO MAKE 50 SERVINGS, YOU NEED:

- 13 to 15 oranges
- Sharp knife
- Cutting board
- Box of 100 3-oz. Dixie cups (use half now, and save the other half . . . you'll probably be in business all summer)

TO DO:

1. Cut each orange in half. Then place each half facedown on the cutting board and cut each half in half. Then slice each half in half again. Each orange will yield 8 wedges.

2. Place two wedges in each Dixie cup.

3. Go to a sporting event and aggressively peddle your wares. The going rate is 50 cents per 2-wedge cup.

BUSINESS PLAN TWO: *LEMONADE*

There's lemonade and then there's Lemonade. Set up shop at the end of a driveway or alongside of a road with a low speed limit (25 mph or less) and watch the money start piling up. It's hard to resist the pull of lemonade on a hot summer day. In other words, when life gives you lemons, make money.

TO MAKE ONE 2-QUART PITCHER OF LEMONADE, YOU NEED:

- 10 to 12 lemons
- Sharp knife
- Cutting board
- Strainer
- Pitcher
- 2 cups superfine sugar
- 6 cups water
- Great signage
- Table
- Chair
- 25 3-oz. Dixie cups

TO DO:

1. Make the lemonade. Cut your lemons in half. Place the strainer over the pitcher and squeeze each lemon half over the strainer—it will catch the pulp and seeds. Set the strainer aside and add the sugar and water to the pitcher. Stir and refrigerate.

2. Scope out your spot. Once you've figured out where you want to set up shop, create some killer signs using neon colors and slogans. Really go all out. There is a lot of competition out there and that competition is sour and comes from a mix. You don't want to mess around with those cheaters over on ELM STREET.

3. Place your irresistible lemonade out on the table and sit in your chair. If there are more cars than pedestrians, you may want to stand behind your table to get the drivers' attention.

4. Charge between 50 and 75 cents to be competitive. Customers can always buy more once they know your supply is good.

Note: If you have a willing grandmother or baking-enthused friend, you may want to have a lemonade/cookie stand to really close the deal.

PLAN ONE

BEFORE ⊐

ACCOUNTING		
SUPPLY:	COST:	
		-
		-
		-
		-
		-
		-

↓ AFTER

CUSTOMERS:	TALLY:	UNITS CONSUMED:	PROFIT:
			+
			+
			+
			+
			+
			TOTAL PROFIT:

PLAN TWO

BEFORE ⊐

SUPPLY:	COST:	
		-
		-
		-
		-
		-
		-

↓ AFTER

CUSTOMERS:	TALLY:	UNITS CONSUMED:	PROFIT:
			+
			+
			+
			+
			+
			TOTAL PROFIT:

FREE
SPACE

PASTE A PHOTO OF EACH OF YOUR FRIENDS
BESIDE A HEART CUTOUT OF THEIR
FAVORITE CANDY WRAPPERS.
ARRANGE TASTEFULLY.

DESCRIBE A VICTORY YOU AND YOUR PALS HAD RECENTLY.

IT CAN BE SPORTS RELATED . . . OR NOT.

TOP 10 BEACH/POOL SONGS:

10. _____

9. _____

8. _____

7. _____

6. _____

5. —————————————

4. —————————————

3. —————————————

2. —————————————

1. —————————————

GET TO KNOW THE CLASS

NAME:	GOES BY (NICKNAME):
(EXAMPLE) EMILY	EM

CATCH PHRASE:

SERIOUSLY?

MOTTO:

WORK HARD, PLAY HARD.

WATER SUPERLATIVES

MOST LIKELY TO DATE A LIFEGUARD

BEST CANNONBALL

MOST LIKELY TO BE A LIFEGUARD

WORST SWIMMER

UNOFFICIAL PATH TO GOLD MEDAL GLORY
IN 3 SUPER-EASY DIVING LESSONS*

THE
CANNONBALL

Stand by the side of a pool/lake that is 5 feet deep or more. Jump up and toward the water and quickly tuck your knees into your chest, wrapping your arms around your legs. Close your eyes and get ready for a big splash.

THE
BELLY FLOP

Stand by the side of a pool/lake that is 5 feet deep or more. Straighten your arms and clamp them to the sides of your body while drawing your legs and arms closely together so you resemble a plank. Close your eyes and let yourself tip forward, landing flat on the water. One-piece swimsuit recommended.

THE
LAZY JUMP

Stand by the side of a pool/lake that is 5 feet deep or more. Step in. Congrats! You're a diver.

SCOREBOARD SCALE 1—10	
01	WOULDN'T GO IN
10	FISH

* Never dive in an area that expressly prohibits it; also, best to find one that comes with a lifeguard.

CONTESTANT NAME	LAZY JUMP	CANNONBALL	BELLY FLOP
(EXAMPLE) CLARA	10	3	1

EVERY GREAT BODY OF WATER, BE IT A YMCA POOL OR LAKE LOCH NESS ITSELF, HAS A LEGEND. WRITE THE LEGEND OF HOW YOUR SWIMMING HOLE CAME TO BE. FEEL FREE TO EMBELLISH, FOR LEGEND'S SAKE.

GRAB SOME FRIENDS AND TAKE TURNS RECORDING QUOTES YOU ABSOLUTELY LOVE THIS SUMMER—THEY CAN BE POEMS, SONG LYRICS, OR THINGS YOU'VE SAID TO EACH OTHER. BE SURE TO ATTRIBUTE EACH QUOTE TO ITS SPEAKER AND SAY WHY IT MEANS SOMETHING TO YOU.

TOP 10 <u>CHILL</u> CAMPING SONGS:

10.

9.

8.

7.

6.

HOW TO: MAKE A FREAKING AWESOME BAKED BANANA

Yes, s'mores are delicious, but who has time to hold their arm out over a fire pit all night? Not. You. Grab some friends and some yummy supplies and let the fire do the work while you do the talking.

FOR 6 TO 8 SERVINGS,
YOU NEED:

- Heavy-duty aluminum foil
- 1 12-oz. bag chocolate chips
- 1 16-oz. bag marshmallows (mini or regular; both work!)
- Bananas, peeled (one for each person participating)
- 1 cup chopped nuts (hazelnuts, pecans, or walnuts are good choices; optional)
- Fire (campfire, fire pit, or outdoor fireplace will work)
- Shovel or long tongs

TO DO:

1. Triple fold a 3-foot-long sheet of foil so that it's about 1 foot by 1 foot (three layers thick). Place 1 banana, 1 handful each of chocolate chips, marshmallows, nuts (if using), and anything else you want onto the foil square, combining the toppings evenly over and around the banana. Next, fold the edges of the foil together into a tight pouch, encasing your yummy snack. Make sure everything is securely contained.

2. VERY CAREFULLY, using tongs or a shovel, place the banana pouch into the flaming pits of your campfire. Don't dump it on top, just gently put it at the foot toward the embers. Leave it there for 15 minutes.

3. Remove the banana pouch using the tongs or shovel. VERY CAREFULLLY open the pouch to reveal the delicious melted oozy goodness. Allow to cool for a minute before eating.

Note: If you are hanging out with a larger group, you may want to double the supplies.

RECIPE TESTER NOTES:

ADDITIONS:

CHANGES:

THOUGHTS:

I MADE THESE WITH:

SUMMER SUPERLATIVES

BEST AT ZIPPING THEMSELVES IN A SLEEPING BAG

BEST AT GETTING FIREWOOD

MOST LIKELY TO TAME A WOODLAND CREATURE

BEST STORYTELLER

BEST WITH TENT

MOST LIKELY TO SUGGEST
SINGING KUMBAYA AS A JOKE

BEST AT PICKING
MARSHMALLOW-ROASTING
TWIGS

MOST LIKELY TO SUGGEST
SINGING KUMBAYA AND MEAN IT

MOST LIKELY
TO ATTRACT A BEAR

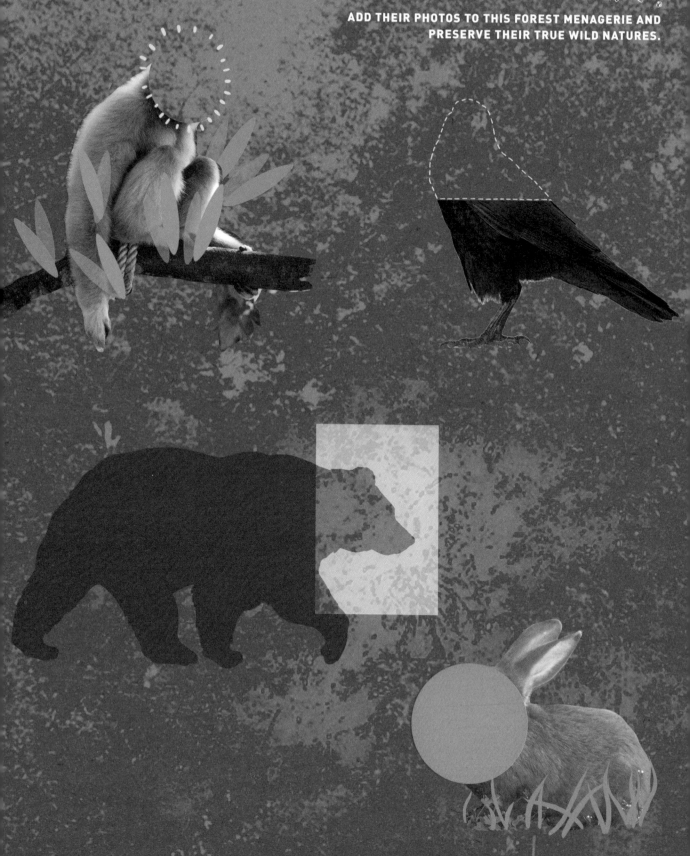

WHICH WOODLAND CREATURE IS MOST LIKE EACH OF YOUR FRIENDS?

ADD THEIR PHOTOS TO THIS FOREST MENAGERIE AND PRESERVE THEIR TRUE WILD NATURES.

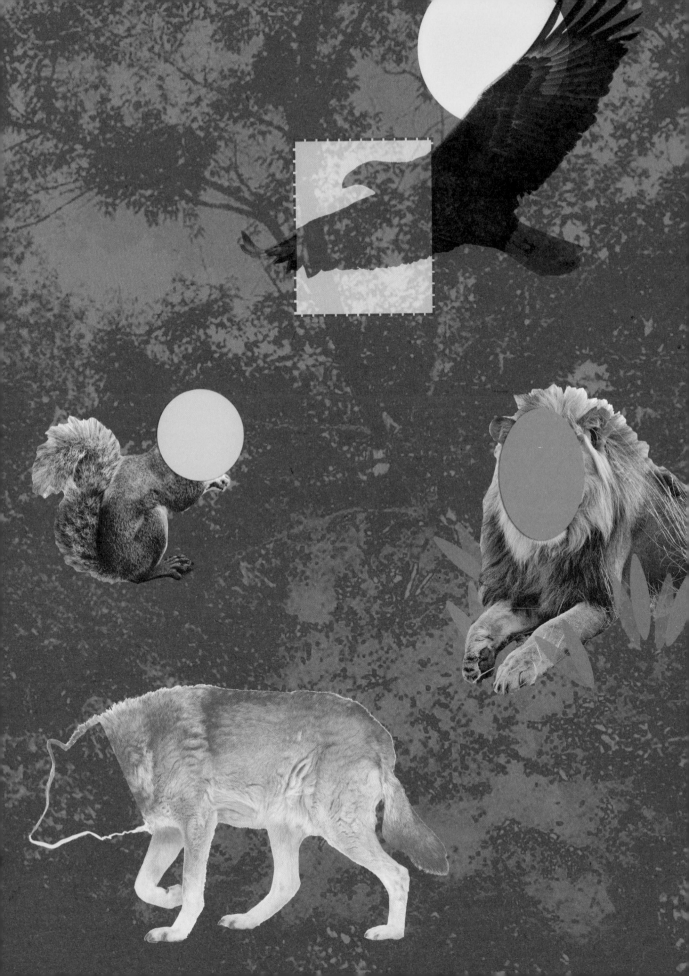

WANT TO HEAR THE SCARIEST GHOST STORY OF ALL TIME?

GREAT—

FIRST YOU HAVE TO WRITE IT. HAVE YOUR PALS SIT AROUND THE CAMPFIRE AND EACH WRITE A SENTENCE OF THIS GHOST STORY UNTIL YOU RUN OUT OF SPACE. MAKE THE TALE MORE SUSPENSEFUL WITH EACH PASSING SENTENCE. READ IT OUT LOUD WHEN YOU'RE DONE AND SEE WHO GETS THE MOST SCARED.

BOO!

411

NAME	HOMETOWN	PET
(EXAMPLE) MARY	SPRINGFIELD	DOG (TAMMY)

411

BEST FRIEND	WORST ENEMY	FUN FACT
Rose	MATH	CAN PLAY MANDOLIN

TOP 10 SONGS TO SPACE OUT TO:

10. _____

9. _____

8. _____

7. _____

6. _____

HOW TO: MAKE A DREAM CATCHER

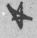

YOU NEED:

- 30 yards of yarn (one or more colors, it's up to you), give or take
- Two thin wooden dowels, pencil or Popsicle sticks

(A)

(B)

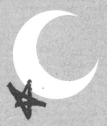

1. Tie the end of the yarn around one dowel in the center.

2. Cross dowels so that they intersect each other in the middle like a cross. Pinch them together with your left han d so that they stay in place.

3. Using your right hand, wrap the yarn around the dowels through upper and lower V 10 times.

4. (A) Shift the dowels 90 degrees to the right and wrap the yarn around the new upper and lower V 10 times.

(B) There should now be a thick X in the center holding the dowels in place.

5. Beginning with the dowel nearest the working yarn, wrap the yarn clockwise around that dowel so it forms a loop—pull until it's tight.

6. Next, shift the dowel X 90 degrees to the left and repeat the same clockwise loop around that dowel. Keep repeating this step.

7. The dreamcatcher will start to take shape as you continue to add rows in this clockwise, circular manner. If you would like to change colors, simply cut the working yarn and tie the end to another color, picking up the rotation where you left off.

8. When a large square has formed around your dowels and there is half an inch left exposed at the end of each dowel, tie a double knot around one dowel and cut the yarn, leaving a tail that is a foot long that you can use to tie the dreamcatcher to your bedpost or window.

DREAMS
I'VE HAD...

SUMMER SUPERLATIVES

MOST LIKELY TO HAVE CRAZY DREAMS

MOST SUPERSTITIOUS

MOST LIKELY TO INTERACT WITH A MAGICAL CREATURE

ALWAYS JINX

MOST CLAIRVOYANT

CONSTELLATION NATION

ADD PHOTOS OF YOUR FRIENDS AND DIFFERENT CELEBS WHERE THEY BELONG AMONG THE STARS.

WHAT DO YOU THINK ABOUT WHEN

ASK EACH OF YOUR PALS AND HAVE THEM RECORD THEIR ANSWERS.

YOU LOOK UP AT THE NIGHT Sky?

DESTINED TO BE...

A BIOLOGIST

A HUNTER/ GATHERER

A DEITY

A CELEBRITY

A ROCK STAR

PRESIDENT

A MAGICIAN

A SPY

A WRITER

A PIRATE

AN ADVERTISING EXECUTIVE

A YOGA INSTRUCTOR

A RANGER

A PROFESSIONAL ATHLETE

A MODEL

A CHEF

AN
AUTHOR

A
DANCER

AN
AUCTIONEER

AN
INVENTOR

A
NOMAD

A
PAINTER

A
TALK SHOW
HOST

A
COUGAR

AN
EDITOR

A
CEO

AN
ARTISAN

A
TEACHER

AN
ACROBAT

A
LION TAMER

A
DOCTOR

A
PROFESSIONAL
ORGANIZER

A
SEA CAPTAIN

TOP 10 SONGS TO START THE DAY:

10.

9.

8.

7.

6.

HOW TO ORIENT YOURSELF USING THE SKY

If you live in the Northern Hemisphere, this is for you. If not, we hear Google Maps is pretty good.

THE LITTLE BEAR

POLARIS

BIG DIPPER

1

First, find the Big Dipper (otherwise known as Ursa Major or the Great Bear). It looks like this:

2

Use Ursa Major to find her little sister, Ursa Minor (the Little Dipper/the Little Bear). Using the tip of Ursa Major, trace a diagonal trajectory to the upper right-hand corner of your vision to locate the Little Dipper.

3

The star at the end of the handle of the Little Dipper is known as Polaris— it is the brightest star in this part of the sky. If you walk toward Polaris, you will be heading north.

ORIENTEERING LOG:

SET A GOAL FOR YOURSELF TO GET FROM POINT A TO POINT B USING ONLY THE STARS AS YOUR GUIDE. BE SURE TO GIVE AT LEAST ONE PERSON A HEADS-UP BEFORE YOU GO OUT. RECORD WHAT HAPPENS ALONG THE WAY.

SUMMER SUPERLATIVES

DOESN'T BELIEVE
IN BREAKFAST

BEST ROOM CLEANLINESS

WORST ROOM CLEANLINESS

TAKES LONGEST
TO GET READY

MOST LIKELY TO SEIZE THE DAY

MOST LIKELY TO SLEEP THE DAY AWAY

ROLLS OUT OF BED *READY TO ROCK*

BEST AT EATING BREAKFAST

NOTHING LIKE A PRANK IN THE WEE SMALL HOURS.

CUT OUT WORDS AND LETTERS FROM DIFFERENT PUBLICATIONS AND WRITE A PRANK LETTER TO AN ESTABLISHMENT NEAR YOU! EXTRA POINTS FOR CREATIVE SPELLING.

LOL

GRAB SOME PALS AND
GET UP TO WATCH THE SUNRISE.
WRITE DOWN EVERYTHING YOU SEE.

NOW

NAME	WHERE I AM THIS SUMMER
(EXAMPLE) MAGGIE	CAMP

THEN

WHERE I'LL BE NEXT SUMMER	WHERE I'LL BE IN 5 SUMMERS	WHERE I'LL BE IN 10 SUMMERS
CAMP	NEW YORK CITY	THAILAND

TOP 10 MUSHY/STEAMY SONGS:

10. _____

9. _____

8. _____

1. _____

6. _____

5. _____

4. _____

3. _____

2. _____

1. _____

HOW TO:
MAKE A LOVE POTION ♡

TO MAKE 8 TO 10 SERVINGS OF
EVERLASTING ROMANCE,

YOU NEED:

- 1 to 2 lbs. delicious fresh fruit
- Pitcher
- 1 12-oz. can ginger ale
- Half gallon grape juice or lemonade
- 3- or 5-oz. Dixie cups
- Friends

TO DO:

1. Cut up/peel/extract/do what you have to do to the fresh fruit and put it in pitcher. Next, add the ginger ale and grape juice. Stir to combine. When the mixture is bubbling, pour it into cups and distribute among your friends.

2. Now discuss your crush in detail—describe your hopes and dreams and let your friends' encouragement or discouragement strengthen the power of the love potion.

3. Once the potion has been drunk, you will feel stronger, as if the crush has been transferred from you onto your crush. And now you will be free to GET BACK TO YOUR SUMMER because you don't have time for that noise anyway.

GRAB SOME FRIENDS AND CARVE (OKAY, DRAW WITH A PEN OR PENCIL) THE INITIALS OF YOU AND YOUR CRUSH INTO THIS TREE BARK WITH A HEART AROUND IT. IT'S CORNY, BUT AT LEAST THIS WAY THE ONLY TREES THAT WILL BE HARMED WERE ALREADY HARMED IN THE MAKING OF THIS BOOK.
* BITES KNUCKLES *

SUMMER SUPERLATIVES

FLIRTIEST DRESSER

MOST LIKELY TO
HAVE A CRUSH ON A
CAMP COUNSELOR

NEVER MAKES
THE FIRST MOVE

HAS
EVERYONE
FOOLED

JOKER

HAS NO ONE FOOLED

ALWAYS MAKES
THE FIRST MOVE

BIGGEST WALLFLOWER

DIRTIEST DANCER

BIGGEST FLIRT

HOTTEST GUY
OF THE SUMMER

MOST LIKELY TO MAKE A
MOVE ON THEIR CRUSH

MOST LIKELY TO
HAVE A FAMOUS CRUSH

HOTTEST GIRL
OF THE SUMMER

SUMMER LOVING HAD ME A BLAST

IT'S SUMMER PROM. WHICH MEANS IT'S TIME FOR YOU AND YOUR CELEB CRUSH TO GET
DRESSED UP TOGETHER. FIND SOME PALS, CUT OUT PHOTOS OF YOUR CELEB CRUSHES,
AND DO A LITTLE RETOUCHING (ADD IN PHOTOS OF YOURSELVES)
TO COMMEMORATE A MEMORABLE EVENING.

MASH

DO YOU THINK YOU AND YOUR SUMMER LOVE ARE DESTINED TO BE? Find out using the time-tested method of love prediction: MASH. Grab some friends and play.

1
CHOOSE A FRIEND WHO IS GOING TO BE THE SUBJECT OF THE MASH.

2
NEXT, HAVE THAT FRIEND/ALL YOUR FRIENDS GIVE YOU THE FOLLOWING INFORMATION AND WRITE DOWN WHAT THEY SAY PERTAINING TO THAT FRIEND:
4 potential crushes,
4 potential cities,
4 potential numbers OF KIDS,
4 potential car types,
4 potential pets, and MASH.

3
NOW HAVE THE FRIEND WHO IS HAVING HER FUTURE PREDICTED PICK A NUMBER BETWEEN 1 AND 10 AND GO THROUGH EACH ITEM, ELIMINATING THE ONE THAT FALLS ON THE NUMBER YOU'VE CHOSEN. Keep going, skipping over items that have already been eliminated, until you only have one answer left in each category. To add an extra layer of mystery, you can hide the answers as you do the math and have everyone else guess how it will turn out. When you're finished, read the answers out loud.

AND PEOPLE SAY YOU CAN'T PREDICT THE FUTURE.

MASH

MANSION APARTMENT SHACK HOUSE

CRUSHES

Kevin

xo

CARS

HONDA

CITIES

LA

PETS

CAT

NUMBERS

2

SUMMER IN REVIEW

THE THING EVERYONE
IS SAYING

BEST BOOK

BEST HIP-HOP SONG

BEST SLOW
SONG

*BEST NEW
MOVIE*

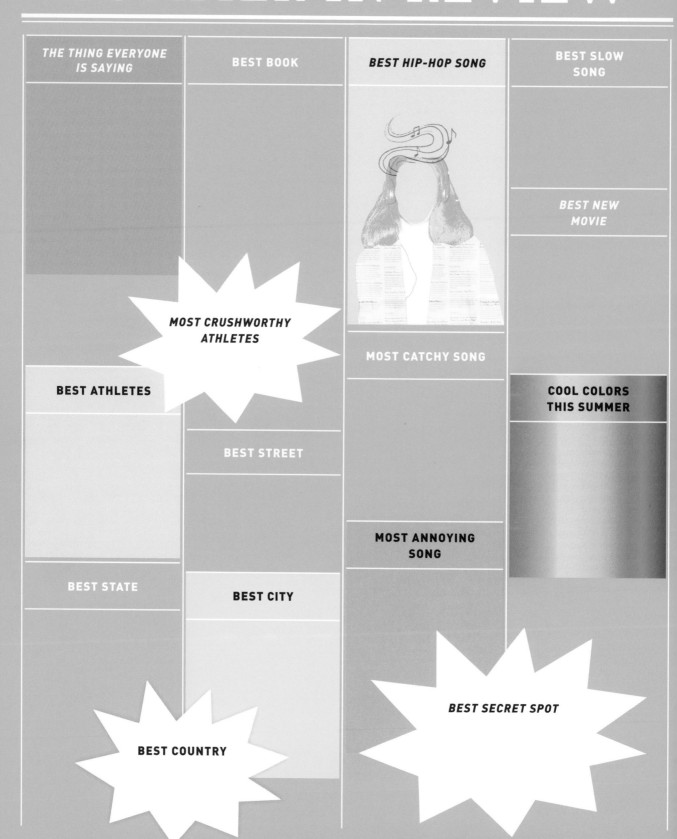

*MOST CRUSHWORTHY
ATHLETES*

MOST CATCHY SONG

BEST ATHLETES

**COOL COLORS
THIS SUMMER**

BEST STREET

MOST ANNOYING
SONG

BEST STATE

BEST CITY

BEST SECRET SPOT

BEST COUNTRY

WORST CAMP

BEST CAMP

BEST WORST
REALITY SHOW

MOST GOALS-WORTHY
ACTORS

MOST BORING
SPORTING EVENT

BEST NEW FOOD

BEST BEACHES

MOST CRUSHWORTHY
ACTORS

MOST ROMANTIC
CELEBRITY COUPLE

WORST REALITY
SHOW

BEST FRIEND

TREND PEOPLE THINK
IS COOL THAT ISN'T

BEST OLD FOOD

BEST TWITTER
TO FOLLOW

BEST INSTAGRAM
TO FOLLOW

BEST STORY

BEST ADVENTURE

WORST POLITICIAN

BEST TV SHOW

BEST SNAPCHAT
FILTER

BEST POOLS

TOP 10 SONGS
THAT REMIND US OF EACH OTHER:

10.

9.

8.

7.

6.

FREE
SPACE

HOW TO MAKE AN ANCIENT STAIRCASE FRIENDSHIP BRACELET

YOU NEED:

- 4 to 6 colors of embrodery thread (1½ yards per each color)
- Safety pin

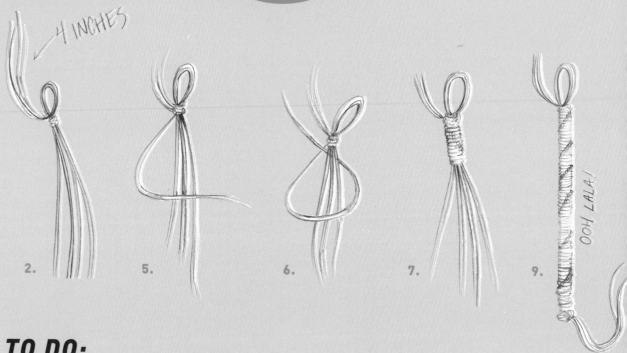

4 INCHES

2. 5. 6. 7. 9.

OOH LALA!

TO DO:

1. Cut each color of embroidery thread into 2½-foot (30-inch) strands.

2. Match up the ends and tie a knot leaving 4 inches of embroidery thread on the short end of the knot. If you know how to do a hangman's knot, you can also do one here, leaving 4 inches outside of the loop.

3. Pass the safety pin through either the knot you have created or the hangman's loop and fasten the pin to the leg of your pants or some material far enough away from you to create tension.

4. Choose one color of thread and tease it out from the others.

5. Cross the thread in front of the others, creating a backward P shape.

6. Wrap the end of the thread around the others, passing it through the bowl of the P and tightening it.

7. Repeat this step 7 times—you will see the staircase pattern begin to appear on the side.

8. Choose the second color, picking it out from the others as you add the first back into the group. Repeat 8 stitches in the second color before switching to the third color.

9. Continue this rotation through all your colors in the order you choose, then begin again with the first color. If you're counting your stitches correctly, each thread should remain approximately the same length.

10. When your bracelet has reached the desired length, tie a large knot at the end using all the threads together.

11. Fasten the bracelet around your/your friend's wrist using the extra embroidery thread on both ends to tie it in place, then clip off the tails.

FRIENDSHIP BRACELETS CAN BE HARD TO KEEP TRACK OF. USING COLORED PENCILS, DO A QUICK SKETCH OF EACH BRACELET YOU AND YOUR FRIENDS MAKE THIS SUMMER, ADDING YOUR NAMES INSIDE THE BRACELETS YOU GAVE TO EACH OTHER.

"CLARA AND LUCY♡

HAVE ALL OF YOUR FRIENDS CUT OUT
AN IMAGE FOR EACH OF YOUR FRIENDS
AND YOURSELF (IF YOU HAVE 4 FRIENDS
INCLUDING YOU, EVERYONE SHOULD HAVE
4 IMAGES). COLLECT EACH PERSON'S
IMAGES INTO A PILE. ARRANGE THE
CUTOUTS IN TASTEFUL CLUMPS AND PASTE
THE IMAGES AROUND A PHOTO OF THE FRIEND
THEY BELONG TO. LABEL THEM AS YOU SEE FIT.

FRIENDSHIP: A MANIFESTO

SIT WITH SOME PALS AND DISCUSS WHAT YOU LOVE ABOUT ONE ANOTHER,
WHAT YOU VALUE, AND WHAT FRIENDSHIP MEANS TO YOU.

THROW IT ALL IN THE POT AND
HOLD NOTHING BACK.
THEN WRITE OUT A PACT THAT
WILL HELP YOU STAY
FRIENDS FOREVER.

DON'T FORGET TO SIGN THE PACT. ★

AUTOGRAPHS

AUTOGRAPHS

AUTOGRAPHS